THE DISPUTE

Pierre Carlet de Chamblain de

Marivaux

THE DISPUTE

translated by

Neil Bartlett

OBERON BOOKS

LONDON

First published in 1999 by Oberon Books Ltd.
(incorporating Absolute Classics)
521 Caledonian Road, London N7 9RH
Tel: 0171 607 3637 / Fax: 0171 607 3629
e-mail: oberon.books@btinternet.com

British Library Cataloguing-in-Publication Data
A catalogue record for this book is available from the
British Library.

ISBN 1 84002 108 X

Cover: *The Bolt* by Jean Honoré Fragonard (1732-1806), from an
engraving by Maurice Blot: the Stapleton Collection, reproduction
by kind permission of the Bridgeman Art Library, London and
New York.

Typography: Richard Doust

Printed in Great Britain by MPG Ltd., Bodmin.

INTRODUCTION

ABOUT MARIVAUX

Marivaux was born in 1688, fifteen years after the death of Molière, eleven years before the death of Racine. His work and his century were very different to theirs; Lesage's cynical *Turcaret* (1709) cut all of Molière's selfish, self-important heroes down to size by firmly anchoring its comedy in the economic realities of life; Rousseau, Voltaire and Diderot replaced the hysterical, majestic absolutism of Racine's claustrophobic palaces with an open-minded, almost atheist plurality of fictional, hypothetical worlds. But the century wasn't all sweetness and light; soon after Marivaux's death come the first rumblings of the approaching storm – heard, in very different keys, in *Les Liaisons Dangereuses* in 1782 and in *The Marriage of Figaro* in 1784.

Marivaux started his career in provincial Limoges in 1706, but it really only took off when he started working with the Paris-based Italian comedians (as opposed to the rival French company based at the *Comédie Française*).

Under the leadership of Silvia and Mario Balletti, the company opened Marivaux's *Arlechino Learns about Love* (*Arlequin Poli par L'Amour*) in October, 1720 to considerable acclaim. His next play, *Hannibal*, was a disastrous tragedy, which failed totally at the box office, and after that he wrote only comedies, novels and journalistic articles until his writing career ended in 1757. He died in 1763 in Paris.

ABOUT THE DISPUTE

The Dispute sits halfway, chronologically at least, between Racine and De Sade; no wonder its critical reputation has been so markedly schizophrenic, its text so anxiously scrutinised for signs of a mid-century crisis. It has been derided as artificial, precious, slight, ornamental; acclaimed as theatrical, provocative, many-layered and profoundly disturbing. On the one hand, it is tempting to see it as a charming eighteenth-century bagatelle, a moment of refreshment after the severities of tragedy and before the dark perversities of history – from this perspective, it belongs to the same rococo culture as Kandler's Meissen figurines, the mirrored *boiseries* of a hundred gilded ballrooms, the Pavilion of the Trianon at Versailles, the slight, introspective elegance of Watteau and Lancret. On the other, its narrative seems to presage the eroticism and the intellectual rigour and the cruelties to come – the blush-inducing pornography of Boucher and Fragonard, commissioned to be hung in the private apartments of the insanely wealthy; the relentlessness and amoral inquiry of de Sade's pornographic and political writing; the nearly inhuman superiority to mere human feelings of the pronouncements and visual rhetoric of the French Revolution.

Dark masterpiece or elegant trifle? Both; simultaneously both – that's the whole point.

ABOUT THE ITALIANS

The key to trying to read, translate and stage the play seems to me to lie in the fact that as much as he is the product of his century, there is one thing that makes Marivaux different to all his contemporaries. He spent the whole of his working life writing plays for one

company – the exiled *Comédiens Italiens*, who first played in Paris at the Palais-Royal and the Hotel de Bourgogne in 1716. The company started off playing their native, commedia dell'arte inspired dramas in Italian – then in dumb-show, and then, finally, in French – a French written by Marivaux but made, by him, almost into a new theatrical language, a theatricalised but apparently informal prose that, superficially, couldn't be more different to the robust, loquacious comedy of Molière or the intense, rigorous verse of Racine. Their technique – the art of making a great deal out of almost nothing, constantly ringing subtle and complex changes on the familiar Italian characters and narratives, on the recognisable stage personalities of a fixed acting company – was improvisatory, physical, fluid, personal. They characteristically made a very little text go a long way; and in consequence the comedy – and the inferred yet intense emotion and the erotic charge – is almost all in the situation, not in the lines. The spoken words are the thin ice beneath which depths of danger and hilarity are glimpsed – a useful metaphor, since it hints at what extremely hard work Marivaux is to play, how much invisible sweating the actors have to do to keep the verbal and physical dance of the action fluid and effortless – they, like their characters, have to keep moving, lest the ice crack. A Marivaux actor has to work out all the alarming details of her or his situation – from moment to moment, from phrase to phrase – and then forget them, and start to play. Marivaux characters behave very like actors, in that they are always testing out lines to see if they are true or not, inevitably finding that the games they begin to play spin out of their control. It is no accident that the two scariest (and funniest, and most touching) moments in the life of any

Marivaux character are precisely the same as in an actor's; they reach their crises when they either don't know what their next line is ("I wouldn't know how to put it", says Azor, the first time he tries to articulate his feelings for Eglé) or, even worse, what they are really feeling ("I don't know what's the matter with me", cries Eglé, in real despair) – which is no more and no less than a transcription of the actor's ultimate *cri de coeur:* "I don't know what my character is feeling." In *The Dispute*, Marivaux goes beyond the conventional nightmare of dreaming that you are on stage in a play and can't remember what the next line is; he invents a world, a stage, in which – because no-one in it has ever rehearsed anything, never having met another human being – every line must be invented on the spur of the emotional moment.

It's also worth noting, in passing, that the *Comédie Italien* was very much a women's theatre – literally; the company was run by and dominated by Silvia, Silvia Balletti, the greatest female star in Paris, for whom Marivaux lovingly wrote all of his greatest roles. This is one of the things that makes his theatre very appealing to us; his women are fantastic – independent either both financially or/and intellectually, unapologetic, emotionally adventurous. It is their narratives which are central. Even in *The Dispute*, it is Hermiane who has the first and last lines. It is her relationship with the Prince which not only frames but neccessitates the action. It is the unexpressed but powerful emotion of her first scene – the unspoken sense that the dispute of the title is not some abstract, aristocratic philosophical enquiry but a deeply personal, dangerous area of indecision – should Hermiane trust the Prince, love the Prince, or not? – that gives the whole piece its characteristic air of danger, alarm, weight.

All of this, it must be said, makes Marivaux very difficult to read. There is no playwright who puts less on the page for the actors to work with. It's a rule of thumb with Marivaux that the less is written, the more there is to play.

ABOUT THE COMEDIE FRANCAISE

Every now and then throughout his career – for obvious reasons of finance and prestige – Marivaux would write a text for the *Comédie Française*, but still in the Italian style. Predictably, they couldn't cut it, and the plays flopped. One of these trademark failures was *The Dispute*, in 1744.

By 1744 Marivaux was 56, with over thirty works, including a popular novel, to his name. He was almost at the end of his career; after *The Dispute* there was only one more performed and one more unperformed play to come. The play was booed off the stage at the *Comédie Française* as a failure, and withdrawn after one performance, not to be given again by the company until 1938. It is tempting to see the play as a characteristic 'late work', 'difficult' and consequently unappreciated in its own lifetime and now elevated to greatness by the more discerning, demanding tastes of the late-twentieth century. Certainly, the play has a latent darkness, and a striking asperity of means and theme, that appeals very much to modern taste for the disturbing wisdom of 'late' masterpieces. But actually it is not so unlike other, earlier Marivaux texts. *The Island of Slaves* (1725) is just as political; *The Triumph of Love* (1732) just as philosophical – and also set in the farthest reaches of an aristocratic garden in which some rather nasty experimental tinkering with sex and affection is being staged. But it is

true that in *The Dispute* the characteristic forms of Marivaux's comedy are reduced (or elevated) to a radically economical form. The play is short (a single act of twenty swift scenes), brutal (no set apart from a door and a balcony, no furniture, no big speeches; a series of tight variations on a single theme, namely, noble savages re-enacting Eden) and nasty (I can't think of another plot that veers from innocent clowning to vicious cruelty quite so quickly). All of the characteristic elements of 'Marivaudage' – the elegant scrutinising and re-phrasing of love's every variation and subterfuge are here, but they've been dipped in theatrical acid. What is at stake here is perhaps bigger than in any other Marivaux plot – which is odd, since the action of the play itself seems even by Marivaux's standards slighter and more hermetically enclosed than ever. It is much more than the heroine's happiness. It is nothing less than the nature of being human.

A very up-market topic; but then playing at the *Comédie Française* was clearly, for Marivaux, a very upmarket game.

The play's clinical, fascinated, appalled scrutiny of human nature and behaviour in the raw is, as theatre, far from raw; it is elaborately, if almost invisibly, theatrical. This is, after all, a play that starts with the leading character saying, to an apparently empty set, "I see no sign of the show I was promised." and ends with her screaming, "I can't watch any more of this." It is also a play which makes the voyeurism implicit in all western classical theatre explicit – the audience have their own onstage representatives in the characters of Hermiane and the Prince, privileged spectators who watch, unseen, a company of fellow humans bound to play out a script they are unaware of being ruled by, exhibiting the ludicrous, the sensual and the violent

aspects of human nature to a degree of which we, the spectators, would never dream of condoning in 'real life'.

This heightened, subtle playing with ideas of theatre extends importantly to location and time. The place in which the action takes place is very specific and, suitably, very aristocratic; we are somewhere outside Paris, in that strange place called 'the country'; specifically, in the wooded part of a fashionable eighteenth-century country estate garden known as the 'wilderness' – an artificially contrived contrast with the more formal gardens closer to the house, in which the house guest was expected to wander in the (always fulfilled) hope of coming across an 'unexpected' conversation or amorous encounter – or at the very least a folly or ornamental extravagance like the building in which the Prince has had his noble savages housed. Such wildernesses still survive in the gardens of the Charlottenburg in Berlin or the Lazienowski Palace in Warsaw. (In the Lyric/RSC staging, the action took place in the pre-World War Two twentieth century, with minor society aristocrats staging a perverse fancy-dress, *fête champêtre,* in the now-decayed gardens of just such an unidentified European palace). But for all its historical reality, this place is also strangely unspecific; it is the bare stage of a theatre – as if Marivaux deliberately wanted to reduce the actual theatre of the *Comédie Française* to a pure, essential form. It is also, somehow, not Arcadia, but Eden, a world perfectly formed, but not yet fully inhabited. An Eden without God, perhaps – or, even worse, an Eden in which the scientist-Prince has dared to assume that role.

As for place, so for time. The Prince promises Hermiane – and by extension, the audience – a chance to watch 'the creation of the world'. This is exactly

what we get. Played out in real time, the action of *The Dispute* shows us all of time – from primal self-absorption through Freud's mirror-phase to the refinement of identity through the manipulation of the 'other' to the final, fully socialised stages of erotic choice and social discrimination. Or, to give the mechanics of the play another geometry, from the first day of creation – light (the first daylight of a life spent in a cell) – through the second – space and water (in this case, a prison yard and a puddle) all the way through to the seventh day, with the appearance of the mysterious Adam and Eve couple who are the last characters to come on stage. In the absence of any controlling deity, it is hard to say if their iconic last-minute appearance as the ideal, un-promiscuous couple is meant to be parodic or optimistic.

This time-lapse photographic summary of evolution is most clearly marked in Marivaux's depiction of the growth of language. At the start of the play, the wild children are inarticulate, clumsy in their attempts to quote the language they have learnt but never had to independently use – they barely seem aware, for instance, of the difference between 'person' and 'people', between 'it', 'him' and 'her'; they think 'Man' and 'Woman' are proper names, not categories or genders. These nineteen-year-olds talk almost like toddlers. Just a few pages later, they have learnt, crucially, to lie; and as they lie, so they re-invent before us all the subtleties and complexities of language – specifically, all the twists and turns of the peculiarly sophisticated, easy, elegantly and deliberately phrased language of late Marivaux. Eglé, for instance, whose first sentences are barely articulate, progresses from infantile mimicry through adolescent soliloquizing to Wildean bitchery (the famous two-hander with Adine always reminds me of Cecily

and Gwendolen at tea); then on to adult, agonised, realistic confession (when she tells Carise how she 'really' feels about her two lovers) and finally, beyond realism, into the strange, savage, even obscene farce of the play's concluding scene.

No wonder the classical actors of the *Comédie Française* couldn't make the piece a hit. The play is as extravagantly, bizarrely, self-confidently, self-consciously inventive as the people it contains.

ABOUT MARIVAUX NOW

Without adding, subtracting or altering a word, this is a text which now seems to start in the eighteenth century and end in ours. Whatever Marivaux intended, what he wrote was a story which never was just the aristocratic *jeu d'esprit* promised by the first page. As soon as the Prince describes the set up of his experiment, a twentieth-century audience cannot but be aware of the echoes such an experiment now necessarily has. The question of whether there is such a thing as natural innocence may have been formulated in the eighteenth century, but it still obsesses ours. Are children born bestial? – in which case it is our duty to civilise them – a duty we are terrified of failing; or are they born innocent, issuing from the hand of God or Nature, in which case it is our responsibility to contrive a world which does not corrupt them – a duty we are equally clearly failing to fulfill. These questions reappear every time a sensational image of the beast-child, the infant noble savage, appears to focus them in the popular imagination. The list is long; in the annals of science, Kaspar Hauser; in those of child psychology, Genie, the teenage Los Angeles girl discovered in a locked room in clean-cut 1950's America; in those of tyranny, the anonymous, shaven-headed

subjects of state-sponsored experiment in the concentration camps of the Third Reich, in the brothels of the 'Fascist Republic' of Salo in Northern Italy under Mussolini (as imagined by Pasolini in his *120 Days of Sodom*); in the orphanages of Ceausescu's Romania. In our own country and our own time, two images of children in particular have raised the old questions about the 'natural' goodness or evil of children, two indelible images of the child as liar, of children's games as an arena of unspeakable cruelty; the face of Mary Bell as demonised by the media at the time of her trial, and the video-camera image of Jamie Bolger's killers playing their last game together. We want to forget these pictures, but we can't. Marivaux's text doesn't mean to evoke these questions; but it does.

In Marivaux's *The Game of Love and Chance*, the heroine, Silvia, when finally confronted with indisputable evidence of her own true feelings, admits that she too is in love with the untranslatably beautiful phrase *"Que d'amour!"* – "Such love!" It is a moment of pure enlightenment. In *The Dispute*, when she sees her charges declaring undying love for each other with all the innocence that only total ignorance can guarantee, the wardress Carise bitterly exclaims, *"Que de tendresse."* Like Miranda's "Oh brave new world!", the line holds the audience in a cleft stick of different readings, contradictory feelings. Like the play, it is self-consciously bitter in its awareness of deliberate cruelty, of innocence inevitably spoilt; like the play, it is moving just when it ought to be cynical.

ABOUT THIS TRANSLATION OF THE DISPUTE

This translation is Marivaux, and nothing but – by which I mean there are no additions, excisions or adaptations.

I have had to make one minor verbal alteration to which I would like to confess; the water in which Eglé first sees her face is, in the original French, a *ruisseau* – a stream or, more specifically, the artificial rill or rivulet which was one of the required features of the 'wilderness' of a formal eighteenth-century garden. Because this translation was made to be played in five different theatres in the space of three months, a touring rill presented very real technical and budget problems, and so became a puddle – a not inappropriate image of rococo fantasy fallen on the hard times of the twentieth century. I would of course be perfectly happy for anyone to revert to the original rivulet if they wish to in future.

A few technical points for those unfamiliar with the ways in which Marivaux's texts have been edited and printed. In the original, the exclamations "Ah!" and "Eh!" do not represent specific words or sounds, but indicate only a non-verbal noise or vocal game – in every instance the precise sound and its meanings are the responsibility of the actor. The frequency with which this device is used tells us a lot about the particular improvisatory style of Marivaux's original comedians. It is worth noting that the white characters, when they laugh, laugh "Ah!ah!ah!", while the black characters laugh "Eh!eh!eh!" This may be a precious clue as to the intended difference between the white and black voices in the play – an important issue, given the extraordinary nature of Carise's and Mesrou's parts. Not only are they very rare examples of real black characters in a period drama, they also own the space of the drama – it takes place in a domain over which they have been appointed official custodians – and are onstage more than anyone else. They, like their white charges, are aliens, living in isolation, speaking a language they have been taught – every production must

find its own solutions as to what this means in terms of their vocabulary, accent and vocal attitude.

The stage directions of the surviving earliest edition (1747) have all been strictly adhered to in this translation – it seems to me clear that they are authentic, but also very incomplete. There really ought to be one for every single phrase. The action of *The Dispute* is physical, structured as much by physical games and routines as by verbal ones – again, the importance of this submerged, unliterary element of the text is another indication of the particular techniques of Marivaux's Italian actors.

The lists of characters' names at the start of each scene repay close study; they encode a lot of information about hierarchy and placings on stage.

With regard to punctuation, any translation of Marivaux faces a very real difficulty. The punctuation used in the standard Pleiade edition is largely a late twentieth-century invention. Original eighteenth-century editions preserve a much more fluid punctuation – characteristically, any speech will be strung togther merely with either commas or semi-colons. In Marivaux, a punctuation mark is theatrical rather than grammatical; it indicates that there is a pause, breath or change of thought – but it doesn't tell you of exactly what type. It leaves that to the actor – and remember, Marivaux knew his actors so well it is safe to assume that he knew that they would find the right vocal patterns without any strict prompting from the text. This is a problem for contemporary actors used to discovering patterns of stress and intention in a period text through a scrupulous observation of the difference between commas, semi-colons, colons and full stops. It is also a very real problem for the translator, who must either

preserve an alarmingly informally punctuated original, or invent an entirely personal new punctuation of their own. I have taken the bull by the horns, compared all the available versions, and worked very hard to preserve the idiosyncratic stress patterns of the original, using all my experience as an actor to deduce the liveliest, clearest readings of the original lines. I have deliberately sought not to anglicise the particular combination of abrupt exclamation with fluid, long-breathed confession. I have always tried to preserve one of Marivaux's characteristic verbal constructions: the balanced phrase, in which two complementary thoughts, each with the same number of syllables, are suspended either side of a single punctuation mark. This characteristic sentence or line structure is the last shadow of the Alexandrines of Racine, in which rhyming couplets are built around the fundamental line structure of two six-syllable phrases juxtaposed in a split twelve-syllable line. On four occasions in *The Dispute* (which is of course in prose) the characters speak in unrhymed six-times-two syllable lines – Alexandrines without the rhyme. I've translated them as such. What I'm saying is, the verbal music of Marivaux is as dramatic as anything in Racine, even though he appears to be writing the slightest, most fluid prose imaginable. To think of his prose as being in some way informal, un-exalted, is a fundamental mistake for the actor. It requires phenomenal energy to speak – a task made all the more difficult by the fact that the verbal effort of the characters must almost always appear unconscious. It also requires agonies of translation – never have I spent so long engaged in the Wildean task of spending an hour taking a comma out only to spend another hour putting it back in.

The Dispute is a comedy; the more I get to know the twists and turns of its situations, the more I laugh when I read it. But it is a frightening comedy. It may be useful to end these introductory notes with three quotes which I have found useful when needing to remind myself of the high seriousness with which Marivaux treats the art of enabling actors to show us how 'funny' human beings are.

> "...what can be put into a child by another human being to produce actions entirely incompatible with the intrinsic goodness of the human being as born."
>
> Gita Sereny, *Cries Unheard*

> "Imagine an entire childhood spent in darkness, isolated from the world, with no human contact except an occasional beating. I live with the results of that experiment, and I can tell you the damage was monstrous."
>
> Paul Auster, *City of Glass*

> "I believe that a child who had been brought up in complete solitude, remote from all association (which would be a hard experiment to make) would yet have some sort of speech to express his ideas... But it is yet to be known what language this child would speak."
>
> Montaigne, *Apology for Raymond Sebond*

This translation is respectfully dedicated to the actors who first played it, and to Katie Mitchell, who dared me to do it.

Neil Bartlett,
Lyric Theatre Hammersmith, January 1999.

THE DISPUTE

Characters

HERMIANE

THE PRINCE

MESROU

CARISE

EGLÉ

AZOR

ADINE

MESRIN

MESLIS

DINA

COURTIERS

The action takes place *à la campagne;* in other words,
in the country.

The Dispute was first performed at the *Comédie Française*, Paris, 19 October, 1744. The first performance in this translation was given at The Other Place, Stratford-upon-Avon, 24 February, 1999, and then at The Lyric Theatre Hammersmith on 15 April, in a co-production between the Lyric and the Royal Shakespeare Company.

HERMIANE, Judith Scott

THE PRINCE, Crispin Redman

MESROU, Neil Reidman

CARISE, Adjoah Andoh

EGLÉ, Hayley Carmichael

AZOR, Martin Freeman

ADINE, Charlotte Randall

MESRIN, John Padden

MESLIS, Chris Robson

DINA, Katherine Tozer

The production was directed and designed by Neil Bartlett and lit by Paule Constable.

Sound: Mark Hobbs
Production Manager: Dixie
Costume Supervisor: Brenda Murphy
Company Stage Manager: Monica McCabe
Deputy Stage Manager: Heid Lennard

THE FIRST SCENE

THE PRINCE, HERMIANE, CARISE, MESROU,
THE PRINCE'S RETINUE

HERMIANE: Your highness, where are we going?
The most isolated and godforsaken spot on earth,
apparently – and with no sign whatsoever of the
show I was promised.

THE PRINCE (*Laughing.*): Everything is ready.

HERMIANE: I see nothing; this edifice I'm invited to
enter, what was such a monstrosity constructed for?
Is there some significance to the extraordinarily
high walls around it?

What have you got planned for me?

THE PRINCE: A most original entertainment.

You recall the discussion which lead to us
becoming so animated yesterday – yesterday
evening. You maintained, defying my entire
entourage, that it wasn't your sex, but mine, which
was the first to prove fickle, inconstant. In love.

HERMIANE: Yes, your highness, I maintain that
still. The first inconstancy – let's call it infidelity,
shall we – the first infidelity could only have been
committed by someone shameless enough to blush
at nothing. Well! How could anyone imagine that
women, created innately timid, modest, timid and
modest still despite all the subsequent corrupting
effects of society, how could anyone think that
they would be the first to fall into vices requiring
as much audacity, such emotional promiscuity,

such sheer nerve as those we were discussing. It's hardly credible.

THE PRINCE: Eh, quite, Hermiane, I find it no more likely than you do, but then it's not me you need to convince, I'm on your side even if most people aren't, you know that.

HERMIANE: Yes, out of gallantry; I had noticed.

THE PRINCE: If it is gallantry, it's quite unconscious. It is true I do love you, and that the extravagance of my desire to please you could, easily, influence me to agree with you; but I assure you, any influence has been so subtle I haven't noticed it. Men's hearts are worthless, and you can keep them; I find them incomparably more prone to inconstancy and infidelity than women's; all of them – except mine, and I wouldn't grant even mine the honour of that exemption if I were to be in love with anyone but yourself.

HERMIANE: I detect a trace of irony.

THE PRINCE: For which I will be doubtless duly punished; since I am about to give you the means to damn me, should I not share your views.

HERMIANE: What are you trying to say?

THE PRINCE: Yes, we're going to put the question to Mother Nature herself; she's the only really authoritative judge of such matters – and I'm sure she'll pronounce in your favour.

HERMIANE: Explain. I don't understand you.

THE PRINCE: In order to really know if the first betrayal, the first infidelity was a man's, as you,

and I, assert, one would have to have been there to witness the beginning of the world, of society.

HERMIANE: But one wasn't.

THE PRINCE: But we shall be. Yes – the men and women of those very first days, the world and its first loves – all re-enacted before our eyes just as they were, or at least, just as they ought to have been. It won't be perhaps quite the traditional story, but it will be played out by a traditional cast; you'll see hearts as virgin as Eden, minds as unadulterated as the first minds, pure; perhaps even purer if that is possible.

(*To CARISE and to MESROU.*)

Carise – and you Mesrou – thank you; when it's time for us to retire, use the signal we agreed.

(*To the ENTOURAGE.*)

And, that will be all.

2

HERMIANE, THE PRINCE

HERMIANE: Alright, I'm intrigued.

THE PRINCE: The facts are these: eighteen or nineteen years ago this same current dispute arose at my Father's court, became somewhat heated and remained unresolved. My Father, being of a naturally somewhat scientific bent, and not being in agreement with your position, resolved to decide the matter, by means of an experiment whose conclusions would be irrefutable.

Four newly born children, two of your sex and two of ours, were brought to this wilderness where he had had this accommodation built especially to house them, and where each of them was confined, separately, and where each currently still occupies an enclosure from which they have never strayed, the world beyond which they have never seen. They know no-one except Mesrou and his sister, who reared them – they've looked after them all their lives; they were selected for their colour, so that their charges might be the more astonished when they saw other people. And now for the very first time they'll be allowed the liberty of leaving their cells, and of meeting each other; they've been taught the language we use; one might justifiably regard whatever dealings they choose to have with each other as the first dawn of creation; the very first loves will begin, again – we'll see what happens.

(*At this point, we hear a sound of trumpets.*)

We should take our places promptly, that's the signal warning us our young people are about to appear; there's a gallery runs right round the building from which we'll be able to see and hear them, whichever side they come out. Shall we?

3

CARISE, EGLÉ

CARISE: Eglé, come, follow me; there's a new place here you've never seen. You can run around; it's safe.

EGLÉ: What am I seeing? What a lot of new worlds!

CARISE: It's still the same world, you just never knew its full extent.

EGLÉ: What a lot of country! What a lot of house! I don't think I've been in such a big space ever, I like it and I'm frightened.

(*She looks at and stops at a puddle.*)

What's this water, what's it doing lying on the ground? I never saw anything like that in the world I've come from.

CARISE: No you didn't. That's what they call a puddle.

EGLÉ (*Looking.*): Ah! Carise, come here, come and look at this; there's something living in the puddle that's made like a person, and she looks as surprised about me as I am about her.

CARISE (*Laughing.*): No, that's you you're seeing; all puddles can do that trick.

EGLÉ: What, that's me in there, that's my face?

CARISE: Sure.

EGLÉ: But do you know that's very pretty, that's a lovely thing that is. What a shame I never knew that sooner!

CARISE: It's true you're pretty.

EGLÉ: What do you mean, 'pretty'? Wonderful! What I've found, it's magic... (*She looks at herself some more.*) The puddle's doing all my faces, and I like them all. It must have been lovely for you,

Mesrou and you, having me to look at. I'm going to spend my whole life staring at myself; I'm going to love myself in a minute!

CARISE: Run around if you want to, I'm going to leave you and go back inside your house, there's something I have to see to in there.

EGLÉ: Go, go, I won't get bored, with the puddle.

4

EGLÉ, AZOR

EGLÉ alone for a while, then AZOR appears face to face with her.

EGLÉ (*Continuing and touching her face.*): I'm not tired of myself.

(*And then, catching sight of AZOR, and frightened.*)

What is that, a people like me...

Don't come any closer.

(*AZOR stretches out his arms in admiration and smiles. EGLÉ continues.*)

She's laughing, like she likes the way I look.

(*AZOR takes a step.*)

Wait...

She's very nice-looking really...

D'you know how to talk?

AZOR: The pleasure of seeing you has robbed me of speech.

EGLÉ (*Gaily.*): The people can hear me, and answer me, and she does it so nicely!

AZOR: I'm rapt.

EGLÉ: That's good.

AZOR: I'm delighted.

EGLÉ: I like you too.

AZOR: So why d'you say I can't come any closer?

EGLÉ: I don't say you can't, really.

AZOR: I'll come a bit closer then.

EGLÉ: I'd like that a lot.

(*He advances.*)

Stop a minute... what a state I'm in!

AZOR: I obey, because I'm all yours.

EGLÉ: She obeys; come here at once then, so you can be all mine close up.

(*He comes.*)

Ah! Here she is, it's you; isn't she handsome! really, you're as pretty as me.

AZOR: I'm dying with joy to be beside you, I give myself to you, I don't know what I'm feeling, I wouldn't know how to put it.

EGLÉ: Oh, I'm just the same.

AZOR: I'm happy, I'm upset.

EGLÉ: I'm sighing.

AZOR: It doesn't matter how close I get, I can't get enough of you.

EGLÉ: That's what I was thinking, but we can't see each other properly, not while we're like this.

AZOR: My heart wants your hands.

EGLÉ: There we are, mine gives you them; are you feeling any better now?

AZOR: Yes, but not any calmer.

EGLÉ: That's what's happening to me, we're the same in everything.

AZOR: Oh! – we're so different!; all of me's worth less than your eyes, they're so gentle!

EGLÉ: Yours are so bright!

AZOR: You're so tiny, so fragile!

EGLÉ: Yes, but really it suits you better not being, not as much as me; I wouldn't want you any different; you're perfect, differently; I'll stay the way I am; you stay your way for me.

AZOR: I won't change it at all. I'll be like this always.

EGLÉ: Oh, tell me, where were you when I never knew you?

AZOR: In a world of my own, which I'm never going back to, because you're not there, and because I want to have your hands always; I don't know how to be, without them, and neither does my mouth.

EGLÉ: And my hands can't be doing without your mouth – I can hear noise – it's the people from my world – so you don't scare them, hide in the trees; I'll call you.

AZOR: Yes – but I'll lose sight of you.

EGLÉ: No, you just have to look in any water that's lying around, it's got my face in it, you'll see it.

5

MESROU, CARISE, EGLÉ

EGLÉ (*Sighing.*): Ah! I'm bored already with him being gone.

CARISE: Eglé, I come back and you seem upset, what's happened?

MESROU: Her eyes are brighter than usual.

EGLÉ: That's because there's very big news; you think there's only three of us, well let me tell you, there's four; I have got myself something that's been holding my hand, just now.

CARISE: Who's been holding your hand, Eglé? Eh, why didn't you call for help?

EGLÉ: Help with what? With how good it felt? I was quite alright with it holding it; I said it could; it was kissing it just as much as it could, and I've only got to call it back and it'll kiss it again just to please me. And itself.

MESROU: I know who it is – I thought I spotted him running off – ; this something is called a man – it's Azor; we know him.

EGLÉ: "It's Azor." Nice name! Dear Azor! Dear Man!! ... he's just coming...

CARISE: I'm not at all surprised he loves you and you love him; you were made for each other.

EGLÉ: Exactly, that's what we thought.

(*She calls him.*)

Azor, my Azor, come here, quickly, Man!

6

CARISE, EGLÉ, MESROU, AZOR

AZOR: Eh! It's Carise and Mesrou, they're my friends.

EGLÉ: They just told me all about it, you were made especially for me, me especially for you, they explained it: that's why we love each other so much, I'm your Eglé, you're my Azor.

MESROU: One's the man and the other's the woman.

AZOR: My Eglé, my joy, my enjoyment, my woman.

EGLÉ: Go on, here's my hand, make up for having to hide yourself.

(*To Mesrou and to Carise.*) See, that's what he was doing before, see what I mean about me not needing any help?

CARISE: Children, I already told you, it's only natural you should be so taken with each other.

EGLÉ (*Taking him by the hand.*): It's obvious really.

CARISE: But there's a rule, one rule, if you want to stay in love.

EGLÉ: Yes, I know; you have to be together always.

CARISE: On the contrary, you must sometimes deprive yourselves of the pleasure of seeing each other.

EGLÉ (*Astonished.*): What?

AZOR (*Astonished.*): What?

CARISE: Yes, believe me, otherwise that pleasure will grow less, and you will grow indifferent.

EGLÉ (*Laughing.*): Indifferent, indifferent, my Azor – ha! ha! ha! – what a funny idea.

AZOR: What does she know?

MESROU: Don't laugh, she's giving you good advice; it's only by doing what she just told you, and separating sometimes, that we've stayed in love, Carise and me.

EGLÉ: Yes, well, I can believe that; that's probably true for you sort of people, I mean you're both really black, you must have run a mile when you first saw each other.

AZOR: The best you could ever do, was put up with each other.

EGLÉ: And you'd soon get sick of seeing each other if you had to all the time, because you're not nice to look at at all; me, I love you, for instance, but when I can't see you, I don't miss you, I don't have to see you – why? Because you're not attractive; whereas we do attract each other, Azor and me; he's so handsome, I'm so lovely, so worth looking at, we're rapt just looking at each other.

AZOR (*Taking EGLÉ's hand.*): Just one of Eglé's hands, do you see, just her hand, I ache when I'm not holding it, and when I am holding it, I'll die if I don't kiss it, and then when I have kissed it, I die more.

EGLÉ: Man is right, everything he just said then to you, I feel the same; that's just where we are, and you, you talk about our pleasure, but you don't know what it's like – we don't understand it, and we're feeling it; it goes on for ever.

MESROU: We're not suggesting you separate for more than two or three hours a day.

EGLÉ: Not for one minute.

MESROU: Too bad.

EGLÉ: You're making me cross now, Mesrou; do you think if we look at each other we'll turn ugly? We'll stop being attractive?

CARISE: No, but you'll stop feeling that you are.

EGLÉ: Eh, who's going to stop us feeling it if we are?

AZOR: Eglé will always be Eglé.

EGLÉ: Azor always Azor.

MESROU: I'm sure he will, but you never can tell. Suppose, say, that I turned as good looking as Azor, or Carise turned as beautiful as Eglé.

EGLÉ: What would that have do to with us?

CARISE: Maybe once you'd got sick of the sight of each other you'd be tempted to each leave the other and love us.

34

EGLÉ: Tempted? To leave what you love? What sense would that make? Azor and me, we love each other, that's the end of it, turn as beautiful as you like, why should we mind? That's your business; ours is all done.

AZOR: They'll never understand anything, you have to be us to know what it's like.

MESROU: Up to you.

AZOR: Who I love, it's my life.

EGLÉ: Hear what he said; his life? How could he ever leave me? He's got to live, and I have to too.

AZOR: Yes, my life; how can anyone be so beautiful, look at you so beautifully, have a mouth that beautiful, beautiful everything.

EGLÉ: I love it when he loves me.

MESROU: It's true he adores you.

AZOR: Ah! that's the right word, I adore her! Mesrou understands me, I adore you.

EGLÉ (*Sighing.*): Adore away, but give me a chance to breathe; ah!

CARISE: Such tenderness, even I am touched. But there is only one way to sustain it, which is to take our advice; and if you've got the sense to take it, here, Eglé, give this to Azor, it's something to help him endure your absence.

EGLÉ (*Taking a picture that Carise gives her.*): What's that? I recognise myself; it's me again – and much better than in the water in the puddle, it's got all

how pretty I am, it's really me; how nice to be all over the place! Look, Azor, look at my body.

AZOR: Ah! It's Eglé, it's my woman; there she is – of course the real thing's even better.

(*He kisses the portrait.*)

MESROU: At least it reminds you of her.

AZOR: Yes, it makes you want her.

(*He kisses it more.*)

EGLÉ: There's only one thing wrong with it, I think; when he kisses it, my copy's got everything.

AZOR (*Taking her hand, which he kisses.*): Let's put that right then.

EGLÉ: Oh that...; I want one the same to play with.

MESROU: Choose between his picture and yours.

EGLÉ: I'll take them both.

MESROU: Oh, you have to choose, sorry; I want to keep one.

EGLÉ: Oh well, in that case, I don't need you to have Azor, because I've got his picture already, in my head, so, give me mine, and then I'll have got them both.

CARISE: Here it is in a different version. This is called a mirror; you just press it here to open it. Goodbye, we'll come back and find you later – do, please, think about those little separations.

7

EGLÉ, AZOR

EGLÉ (*Trying to open the box.*): Here, I won't know how to open it; you try Azor – there's where she said you had to press it.

AZOR (*Opens it and looks at himself.*): Right, it's just me, I think, it's my face – a puddle over there showed it me.

EGLÉ: Ha! ha! Let me see! Eh! Oh no it's not, Man, it's me, it's more me than ever, it really is your Eglé, the real one, here, look.

AZOR: Oh yes, it's you, wait, it's both of us, it's half one and half the other; I'd like it better if it was just you on your own, because me being there too stops me seeing all of you.

EGLÉ: Ah! I like seeing a bit of you in it as well, you're not spoiling anything – get in a bit closer – hold on to it.

AZOR: Our faces are going to touch, look now they are touching – that's lucky for mine! that's... rapture!

EGLÉ: I can really feel you, and I really like that.

AZOR: If our mouths got closer...

(*He takes a kiss off her.*)

EGLÉ (*As she turns back.*) Oh! you're messing us up, look, now I can't see anything but me, isn't a mirror a clever invention.

AZOR (*Taking the mirror off EGLÉ.*): Ah! a picture's a good thing too. (*He kisses it.*)

EGLÉ: Carise and Mesrou are good people though.

AZOR: They just want what's best for us; I was going to talk to you about them and that advice they gave us.

EGLÉ: It's about those separations, isn't it? I was wondering about them too.

AZOR: Yes. Eglé, what they said would happen has made me a bit worried. I'm not worried about my end of things, but don't you go and get bored with me, not even a bit, I'd be desperate.

EGLÉ: It's you you should worry about; don't you ever get tired of adoring me – I mean, I know how pretty I am, but your being worried has got me worried too.

AZOR: Oh! you're wonderful, you're not the one who's got anything to be afraid of ... what are you thinking?

EGLÉ: Alright, alright, all things considered, I've made up my mind: let's make ourselves unhappy; let's separate for two hours; I like your love and your adoring me more than your being here, though that's lovely too.

AZOR: Separate? Who? Us?

EGLÉ: Oh! if you don't just do it, in a minute I shan't want to.

AZOR: I can't! I haven't got the nerve.

EGLÉ: That's a shame because mine's fading fast.

AZOR (*Crying.*): Goodbye, Eglé, since we've got to.

EGLÉ: Are you crying? Oh well, stay – so long as there's no danger –

AZOR: But if there is!

EGLÉ: Go on then.

AZOR: I'm going.

8

EGLÉ

EGLÉ (*Alone.*): Ah!, he's not here, I'm on my own.

He's not here any more, I can't hear his voice any more, there's nothing any more but the mirror. (*She looks at herself in it.*)

Getting rid of my Man was a mistake, Carise and Mesrou don't know what they're talking about.

(*Looking at herself.*) If I'd looked at myself properly, Azor needn't have gone at all – you could love what's in there always easily, no need to do this separation thing... Right, I'm going to sit with the puddle, at least it's another mirror.

9

EGLÉ, ADINE

EGLÉ: What's that? It's another person again!

ADINE: Ah! ah! What new thing is this? (*She comes forward.*)

EGLÉ: She's looking at me all over, but not adoring me at all; it's not an Azor. (*She looks at herself in her*

mirror.) And it's even less of an Eglé... However I think it's making comparisons.

ADINE: I don't quite know what to make of that as a look, I couldn't say what it lacks exactly, there's something insipid about her.

EGLÉ: She's the sort of thing I don't like the look of.

ADINE: Has she any conversation?... Let's see... Are you a person?

EGLÉ: Most definitely; I'm my own person.

ADINE: Really. And have you nothing to say to me?

EGLÉ: No. I'm ordinarily more likely to be the topic of conversation than to start one.

ADINE: But you are charmed?

EGLÉ: By you? I'm the one charms people.

ADINE: So you're not pleased to see me?

EGLÉ: Sadly neither pleased nor peeved – should I be?

ADINE: What an extraordinary thing! You stare at me, I let you, and yet you feel nothing. You must have been distracted; a little attention while you study me; there, how do you find me?

EGLÉ: What is it with all this 'you'? Why's it about you? As I say, I'm the one gets looked at, I'm the one gets told how she looks, that's the way things are done here, and you think I'm going to look at you while I'm around?

ADINE: Of course. In company, the loveliest present must wait, until she's noticed and they're struck.

EGLÉ: So, be struck.

ADINE: You're still not paying attention are you? The loveliest present must wait, as one said.

EGLÉ: As one replies, she's waiting.

ADINE: Well if it isn't me, where is she? All three other people in the entire world are struck dumb by me.

EGLÉ: I don't know these people of yours, but I do know there are three who are rapt because of me and think I'm wonderful.

ADINE: And I know that I am so beautiful, so beautiful, that I fascinate myself every time I look at myself, see what I mean?

EGLÉ: What's that supposed to do for me? Every time I stare at myself I'm enchanted, every time, me, me who's talking to you.

ADINE: Enchanted? You may be passable, and even quite... pleasant – I'm being polite now, unlike you –

EGLÉ (*Aside.*): I'd like to shove her politeness right down her throat –

ADINE: – but to imagine any comparison between yourself and myself, well, that would be preposterous, as one can see.

EGLÉ: One is seeing, and finding one quite ugly.

ADINE: In which case, it's your jealousy is blinding you to my beauty.

EGLÉ: It's your face that's blinding me actually.

ADINE: My face! Oh! I'm not upset you know. I have seen it. You go and ask the water in any

puddle what it's like, you ask Mesrin, he's mad about me.

EGLÉ: The water in the puddle – which is having you on – would tell me, if asked, that I am the fairest of them all, in fact it's already told me; I've no idea what a Mesrin is, but he wouldn't even look at you if he'd ever seen me; I've got an Azor worth ten times him, an Azor I love, he's almost as attractive as I am, and he says I'm his life; you, you're not anybody's life; and also I've got a mirror which has confirmed everything my Azor and the puddle have told me; beat that.

ADINE (*Laughing.*): A mirror! You've also got a mirror! Eh! And what do you use that for? Admiring yourself! ha! ha! ha!

EGLÉ: Ha! ha! ha! ... see, I knew I wouldn't like her.

ADINE (*Laughing.*): Here's one works properly, take it; learn to recognise yourself and to shut up

(*CARISE appears in the distance.*)

EGLÉ (*Ironically.*): Take but a glance in this one; realise your true mediocrity, and the modesty appropriate in my presence.

ADINE: Go away: since you refuse to take pleasure in the sight of me, you are of no possible use to me, and I'm not speaking to you any more.

(*They stop looking at each other.*)

EGLÉ: And I don't even know you're there.

(*They keep their distance.*)

ADINE (*Aside.*): She's mad!

EGLÉ (*Aside.*): She's seeing things – what world is she from?

10

CARISE, ADINE, EGLÉ

CARISE: So what are you two doing so far apart, and not speaking?

ADINE (*Laughing.*): It's a new person, who I met by accident, and whom my beauty has driven to distraction.

EGLÉ: What do you make of this faded thing, this ridiculous specimen; who aspires to striking me, who asks me how I feel when I look at her, who expects me to take pleasure in the sight of her, who instructs me: Eh! Gaze upon me now! Eh! How d'you find me! and who claims she's as beautiful as I am!

ADINE: I didn't say that, I said more beautiful, as one can see in the mirror.

EGLÉ (*Showing hers.*): And what can she see in this one – as if she'd dare!

ADINE: I'm only asking that she glance in mine – which is the more accurate.

CARISE: Gently, no need to get carried away, treat the accident of your meeting as a happy one instead; let's all be together; you make friends; and then you can add the joy of being together to the pleasure of both being adored, Eglé by the lovely Azor, who she loves, Adine by the lovely Mesrin, who she loves; come on; make it up.

EGLÉ: Only if she ditches her tedious delusions of grandeur.

ADINE: Listen, I know what'll knock some sense into her; I'll just have to take her Azor off her − not that I want him, but anything for a quiet life.

EGLÉ: Where is this Mesrin idiot of hers? If I meet him, she's had it! Goodbye, I'm taking myself off now, because I simply can't bear her.

ADINE: Ha! ha! ha! ... present company being too unbearably distinguished.

EGLÉ (*Coming back.*): Ha! ha! ha! ... what a nasty face!

11

ADINE, CARISE

CARISE: Sticks and stones... let her say what she likes.

ADINE: Really − absolutely; I feel sorry for her.

CARISE: We have to leave, it's time for your music lesson; I shan't be able to give it to you if you loiter.

ADINE: I'm coming − oh I can see Mesrin; just a quick word −

CARISE: You've only just left him.

ADINE: I won't be a minute −

12

MESRIN, CARISE, ADINE

ADINE (*Calling.*): − Mesrin!

MESRIN (*Running.*): What! It's you, it's my Adine, she's come back; Oh I'm so happy! Oh I was getting so impatient!

ADINE: Look, no – don't be too happy; I haven't come back, I'm just going; I just happen to be here.

MESRIN: So now you'll have to just happen to be with me.

ADINE: Listen – listen what happened to me – ,

CARISE: Keep it short please: I do have other things to do.

ADINE: I am – (*To MESRIN.*) I'm beautiful, aren't I?

MESRIN: Beautiful! Are you beautiful?

ADINE: See, no hesitation; speaks as he finds.

MESRIN: Are you Divine? Beauty Incarnate!

ADINE: Well yes, of course I am; however; you, Carise and me, we've got it all wrong, I'm ugly.

MESRIN: My Adine?

ADINE: No less; after I left you, I found a new person, female, from another world, who, instead of being amazed by me, being transported by me like you are and like she should have been, wanted instead for me to be charmed by her, and when I failed to oblige, accused me of being ugly –

MESRIN: You're going to make me lose my temper!

ADINE: – informed me you'd leave me once you'd seen her.

CARISE: That was because she was angry.

MESRIN: But – this is a person?

ADINE: So she says, and she looks like one, more or less.

CARISE: And she is one.

ADINE: She'll doubtless be back, and I absolutely insist you treat her with contempt; when you meet her, I want you to be appalled.

MESRIN: She must be really hideous.

ADINE: She's called... oh... no, wait – ... she's called...

CARISE: Eglé.

ADINE: That's right, it's an Eglé. She is currently sporting: an angry face, sullen; not as black as Carise's but not quite as white as mine either; it's a colour one would be hard put to describe.

MESRIN: But it's not a nice colour?

ADINE: Oh not at all nice, more sort of dull; she's got eyes – now how can I put this – eyes that don't look lovely, they just look, really; mouth, not big, not small – a mouth made for talking; she stands upright, vertical – and her figure would be a bit like mine if she were a better shape; hands that come and go; long, thin fingers, I think; with a nasty, rude voice – oh! you're bound to recognise her.

MESRIN: I can just see her; you leave it to me: she wants sending back to this another world – after I've really mortified her.

ADINE: Really humiliated, really finished her.

MESRIN: Had a really good laugh at her – oh! don't you worry, you just give me that hand.

ADINE: Eh! Here it is, I only have them for you.

(*MESRIN kisses her hand.*)

CARISE (*Taking the hand off him.*): Right, all done, let's go.

ADINE: When he's finished kissing my hand.

CARISE: Leave it now, Mesrin, I'm late.

ADINE: Goodbye my only love, I shan't be long; dream of vengeance.

MESRIN: Goodbye, my only reason for living; I am all fury.

13

MESRIN, AZOR

MESRIN (*The first words on his own, repeating the description.*): Colour not black or white, standing upright, mouth talking... where am I going to find one of those? (*Seeing AZOR.*) There's someone over there; it's a person like me; maybe that's the Eglé? No, she's not deformed at all.

AZOR (*Staring at him.*): You're like me, aren't you?

MESRIN: That's what I was thinking.

AZOR: You're a man then?

MESRIN: So they told me.

AZOR: That's what they told me too.

MESRIN: They told you: do you know people?

AZOR: Oh yes I know them all, two blacks and one white.

MESRIN: Me, I'm the same. Where do you come from?

AZOR: From the world.

MESRIN: D'you mean mine?

AZOR: Ah!, I don't know, there's so many now.

MESRIN: Doesn't matter, I like the look of you; put your hand in my hand; we ought to fall in love.

AZOR: Right-oh; you cheer me up, I like looking at you even though you're not good-looking.

MESRIN: You're not either; I'm not bothered, about you, except you're a good chap.

AZOR: That's right, that's the same way I think about you, as a good friend – and I'm a good friend too – what's faces anyway?

MESRIN: Eh! whatever; I'm high-spirited, you see, that's why I'm staring at you. By the way, do you get meals?

AZOR: Every day.

MESRIN: Oh good; I get them too; well, let's eat them together, for fun, keep ourselves in the mood; come on, it's nearly time: we'll have a laugh, we'll have a jump, right? I'm jumping already.

(*He jumps.*)

AZOR (*He's jumping too.*): Me too, and we'll be a pair
– maybe a four, when I tell my little white one –
she's got a face: – you've got to see it! ah! ah! she's
the one's got one worth two of ours.

MESRIN: Oh! I believe it, mate; because you're
nothing, really nothing, nor me neither, compared
to this other face I know, who we'll get together
with, who drives me crazy, and she's got these
hands, so sweet, so white, – and she lets me kiss
them – so much!

AZOR: Hands, mate? My white one's got heavenly
ones, hasn't she – and I stroke them as much as I
like, don't I? I'm waiting for them.

MESRIN: Great, I've just left mine, and now I've
got to leave you too to get on with something; you
stay here 'til I come back with my Adine – let's
jump one more time, to celebrate this auspicious
encounter –

(*They both jump, laughing.*)

Ah! Ah! Ah!

14

AZOR, MESRIN, EGLÉ.

EGLÉ (*Approaching.*): What is that that's making you
so happy?

MESRIN (*Seeing her.*): Ah! there's a beautiful thing
listening to us!

AZOR: That's my white one – that's Eglé.

MESRIN (*Aside.*): Eglé – that's Angry-face?

AZOR: Ah! I am so happy!

EGLÉ (*Approaching.*): Some sort of new friend who's appeared amongst us all of a sudden?

AZOR: Yes, it's a friend I've made, he's called Man, and he's come from a world near here.

MESRIN: What a nice time one has in this one!

EGLÉ: Nicer than in yours?

MESRIN: Oh absolutely.

EGLÉ: Well, Man, you'll just have to stay here.

AZOR: That's what we were saying, because he's altogether decent and a good thing; I love him – not like I love my lovely Eglé who I love, whereas with him I'm really not bothered, it's just he's the only one I want to spend time with, talking about you, your mouth, your eyes, your hands, that I've been aching for.

(*He kisses one of her hands.*)

MESRIN (*Taking her other hand.*): I'll just take the other one then.

(*He kisses that hand, EGLÉ laughs, and doesn't say a word.*)

AZOR (*Taking that hand back off him.*): Oi! – steady; this isn't your white one here, it's my one, these hands are both mine, there's none for you.

EGLÉ: Oh! no harm done; but, on that topic, off you go, Azor; you know how necessary separation is, well, ours hasn't been long enough.

AZOR: What! It's been – I don't know how many – hours, hours I haven't seen you.

EGLÉ: You're wrong; it hasn't been long enough, actually; I do know how to count, and what I've decided, I like to stick to.

AZOR: But you'll be here on your own.

EGLÉ: I'm sure I'll be alright.

MESRIN: Don't upset her, friend.

AZOR: I think you're angry with me.

EGLÉ: Why are you being so pigheaded with me? Did you or did you not say there was nothing as dangerous as us seeing each other?

AZOR: That may not be true.

EGLÉ: Personally I suspect it's not a lie.

(*CARISE appears here, at a distance, and listens*.)

AZOR: Alright I'll go, to make you happy, but I'll be back, soon; let's go, friend, friend who said he'd got something to get on with, you can come with me and help me pass the time.

MESRIN: Yes, but...

EGLÉ (*Smiling.*): What?

MESRIN: Well I've been walking around for ages.

EGLÉ: He really ought to rest.

MESRIN: And I could see that the lady doesn't get bored.

EGLÉ: Yes, he could see to that.

AZOR: Didn't she say she wanted to be on her own? Otherwise I'd unbore her much better than you. Let's go!

EGLÉ (*Aside, and vexed.*): Yes, right, go.

15

CARISE, EGLÉ

CARISE (*Approaches and looks at EGLÉ who is dreaming.*): What are you dreaming about?

EGLÉ: I'm dreaming I'm not in a good mood.

CARISE: Are you sad?

EGLÉ: I'm not sad at all, I'm over-sensitive.

CARISE: About what?

EGLÉ: You told us before that when you are with someone you never know what's going to happen?

CARISE: That's correct.

EGLÉ: Well, I don't know what's going to happen to me.

CARISE: But what's the matter with you?

EGLÉ: I suppose I'm angry with myself: I'm angry with Azor – I don't know what's the matter with me.

CARISE: Why angry with yourself?

EGLÉ: Because I had a plan I was going to love Azor for ever, and now I'm afraid I'm not going to.

CARISE: Would that be possible?

EGLÉ: Yes – and I'm angry with Azor, because it's his behaviour started it.

CARISE: I suspect you want to quarrel with him.

EGLÉ: You just carry on answering me like that every time, I'll be angry with you too in a minute.

CARISE: You are in a bad mood; what has Azor done to you?

EGLÉ: What has he done? We agree to separate, he goes, he comes back, immediately, he wants to be there all the time, and in the end what you told him would happen to him will happen.

CARISE: What? You'll stop loving him?

EGLÉ: Of course; if the pleasure of seeing each other goes when you've had it too often, is that my fault?

CARISE: You told us you were sure that could never happen.

EGLÉ: Don't split hairs with me; what did I know? I was sure because I was ignorant.

CARISE: Eglé, it can't be his over-eagerness to see you that makes his proximity so irksome, you haven't known him long enough.

EGLÉ: Quite a while; we've already had three conversations together, and apparently it's prolonged encounters that are forbidden.

CARISE: You still haven't said what actual wrong he's done.

EGLÉ: Oh! he's done the odd one or two, he's done I don't know how many: number one, he forbids me; my hands are mine, I think, they belong to me, and he decides they shouldn't be kissed.

CARISE: And who was it wanted to kiss them?

EGLÉ: Some friend he'd acquired all of a sudden, he's called Man.

CARISE: And he's attractive.

EGLÉ: Oh! Gorgeous, nicer than Azor, and he even offered to stay and keep me company; and that lunatic Azor wouldn't let him have either the hand, or the company, told him off and dragged him away all of a sudden, without asking what I wanted: Ah! ah! So I don't run my own life now, I can't be trusted now, afraid someone might love me now is he?

CARISE: No, but he is afraid that his friend might attract you.

EGLÉ: Well, all he's got to do is attract me more then, because if it's a question of being loved, I'm very happy to be, is that clear, and if instead of one friend, he had a hundred, I'd want them all to love me, that's what I like; he wants me beautiful just for him, and I, I think I should be anybody's.

CARISE: Listen; your loathing for Azor has got nothing to do with all that, but it has got everything to do with the fact that you currently love his friend more than you do him.

EGLÉ: D'you think so? I suppose you could be right.

CARISE: Eh! Tell me, don't you feel any shame at all about being unfaithful?

EGLÉ: Apparently yes; I'm blushing; I'm still ignorant that way you see.

CARISE: Ignorance has nothing to do with it; you promised, and often, to be faithful to him.

EGLÉ: Listen, when I promised that, he was the only one, he should have stayed the only one, I didn't count on there being a friend.

CARISE: Admit it, that's no argument for changing your mind – as you yourself once pointed out.

EGLÉ: Alright, it's not up to much; but there is one really good one, which is that the friend's better than Azor.

CARISE: Still fooling yourself; the reason you prefer him is not that he's better, it's that he's new.

EGLÉ: A quite considerable advantage, don't you think; or doesn't being new count? Doesn't being someone else count? At least it's fun, it's attractive in a way Azor isn't.

CARISE: Plus the new arrival is going to fall in love with you.

EGLÉ: Exactly, he is going to fall in love with me, I hope, that's rather attractive too.

CARISE: Whereas Azor isn't going to fall in love with you.

EGLÉ: Well no, he loves me already.

CARISE: What a funny reason for a change of heart! I'd lay good money you're not happy with it.

EGLÉ: I'm not happy with anything; on the one hand
changing hurts, on the other, it's a pleasure;
I can't stop myself feeling one any more than the
other. They both matter to me; which one do I
owe most? Should I hurt myself? Should I please
myself? Tell me. I dare you.

CARISE: Ask your heart; it'll tell you how much it
hates infidelity.

EGLÉ: You're just not listening; my heart hates it, my
heart recommends it, it says yes, it says no, it's in
two minds; and all I've got to do is choose the
most convenient option.

CARISE: Do you know what you should do? Avoid
Azor's friend; let's go, come on, you don't have to
struggle like this –

EGLÉ (*Seeing MESRIN coming.*): No; but we've left it
too late: look, the struggle's on its way over – the
friend is unavoidable

CARISE: Never mind, force yourself, be brave, don't
look at him.

16

MESROU, MESRIN, EGLÉ, CARISE

MESROU: (*From a distance, trying to hold MESRIN
back, who is getting away.*) I can't hold him – he
fancies being unfaithful – stop him getting to her.

CARISE: (*To MESRIN.*) That's close enough.

MESRIN: Why.

CARISE: Because I say so; Mesrou and I must have some authority over you, we're your masters.

MESRIN (*Turning.*): My masters? What's a master?

CARISE: Alright, I won't tell you to, I'll ask you to, and the lovely Eglé also subscribes to my request.

EGLÉ: Me! No I don't, I don't subscribe to requesting.

CARISE (*Aside, to EGLÉ.*): Let's go back inside; you still don't know that he loves you.

EGLÉ: Oh, but I don't hope he doesn't; he'll just have to be asked.What do you want, pretty little friend?

MESRIN: To see you, to look at you, gaze at you, call you my life and soul.

EGLÉ: See, he's talking about his soul; do you love me?

MESRIN: To perdition.

EGLÉ: What did I tell you?

MESRIN: Do you love me too?

EGLÉ: I'd rather not have to unless I have to, because of Azor – he's depending on me.

MESROU: Mesrin, do like Eglé; no need to be unfaithful at all.

EGLÉ: Mesrin! Man's called Mesrin!

MESRIN: Eh, yes.

EGLÉ: Who is Adine's friend.

MESRIN: Who was; and who now has no further need of her picture.

EGLÉ (*Taking it.*): Adine's picture, and Adine's friend; yet another attraction. Ha! ha! Carise, so many good points, how can I resist; Mesrin, come here and let me love you.

MESRIN: Ah! what a lovely hand I've got.

EGLÉ: What a special friend I've gained.

MESROU: Why are you leaving Adine? Because she's done something wrong?

MESRIN: No, because there's a beautiful face says I have to.

EGLÉ: Because he's got eyes, that's why.

MESRIN: Oh! I know what I'm doing, but there's nothing I can do about it.

EGLÉ: Right, I'm making him do it; we're making each other do it.

CARISE: Azor and she will be in despair.

MESRIN: Too bad.

EGLÉ: What can one do?

CARISE: If you want me to, I know how to use their being in love to stop them being hurt.

MESRIN: Well then, do it.

EGLÉ: No, don't; I'd be quite happy to have Azor suffer over me; beauty like mine deserves to be regretted; and there also wouldn't be much wrong with Adine having to sob for a bit, it'll teach her not to overrate herself.

17

MESRIN, EGLÉ, CARISE, AZOR, MESROU

MESROU: Azor's here.

MESRIN: How embarrassing, he's my friend – he's going to get an awful shock.

CARISE: From the look of him, I'd say he's already guessed the wrong you two have done him.

EGLÉ: Yes, he does look sad; ah! he's got good reason to be.

(*AZOR comes forward shamefacedly; she carries on.*)

Are you upset, Azor?

AZOR: Yes, Eglé.

EGLÉ: Very?

AZOR: Really.

EGLÉ: Evidently, eh! How can you tell I love Mesrin?

AZOR (*Astonished.*): What?

MESRIN: Yes, my friend.

AZOR: Eglé loves you? She doesn't care about me any more?

EGLÉ: It's true.

AZOR (*Joyful.*): Eh! Fantastic; carry on, I don't care about you either – hang on, I'll be right back –

EGLÉ: You hang on, what are you trying to say, you don't love me any more, what's that supposed to mean?

AZOR (*As he is going.*): You'll see in a minute.

18

MESROU, CARISE, EGLÉ, MESRIN

MESRIN: You're calling him back, aren't you, eh, what's that all about? What's he got to do with it, now you love me?

EGLÉ: Oh, leave me alone, I'll love you more, if I can get him too; it's just I don't see why I have to give anything up.

CARISE and MESROU (*Laughing.*): Eh! Eh! Eh! Eh!

EGLÉ: Oh that's funny is it?

19

MESROU, CARISE, EGLÉ, MESRIN, ADINE, AZOR

ADINE (*Laughing.*): Hello, it's the lovely Eglé; should you ever want to see what you're really like, do let me know, I've got your picture; I got given it.

EGLÉ (*Throwing her her picture.*): Here, I may as well give you yours back, there's hardly any point in me keeping it.

ADINE: What, Mesrin, my picture! And how come she's got it?

MESRIN: Because I gave it to her.

EGLÉ: Well then, Azor, come here and let me talk to you.

MESRIN: Talk to him? What about me?

ADINE: Come here, Mesrin, what are you doing over there, I think you're being ridiculous.

THE FINAL SCENE

MESROU, CARISE, EGLÉ, MESRIN, THE PRINCE, HERMIANE, ADINE, MESLIS, DINA, AZOR

HERMIANE (*Entering at a pace.*): No, let me go, your Highness; I can't watch any more of this; I find this Adine and this Eglé intolerable; your random selection has chanced upon two specimens exemplifying everything that has ever been contemptible in my sex.

EGLÉ: Who are all these people, coming on roaring? Run for it.

(*They all try to run.*)

CARISE: Stay where you are, all of you, there's nothing to be afraid of; here are some new friends, just arrived; don't scare them; see what they think.

MESLIS (*Stopping in the middle of the theatre.*): Ah! Dina – so many people.

DINA: Yes, but they've got nothing to do with us.

MESLIS: That's right, there isn't one that looks like you. Ah! It's you, Carise and Mesrou; are these all men or women?

CARISE: Same number of women as men; there's the one, and here's the other; have a look through

them, Meslis; see if there's one of the women you like the look of more than Dina; they'll give her to you.

EGLÉ: I'd like to be his friend.

MESLIS: No point in liking what you can't have.

CARISE: Choose another one.

MESLIS: Thank you very much, it's not that I don't like them, but I just don't care for them, there's only one Dina in the world.

DINA (*Putting her arm through his.*): That's right.

CARISE: What about you, Dina, take a look.

DINA (*Taking him by the arm.*): I've seen everything I want to see, let's go now.

HERMIANE: What a charming girl! I'll see to her education.

THE PRINCE: And I'll see to the boy.

DINA: We're alright just the two of us.

THE PRINCE: You won't be separated; thank you, Carise – have them put to one side, and have the others taken care of as per my instructions.
(*And to HERMIANE.*) So, Madam, it seems neither sex has anything with which to reproach the other; vices, virtues, both have both.

HERMIANE: Ah! Please, allow some distinction; your sex's treachery is disgusting; you change partners without reason, without even bothering with an excuse.

THE PRINCE: I admit, the way yours does it is at least more hypocritical, and consequently more acceptable; you make more of a fuss about your conscience than we do.

HERMIANE: Believe me, we've got nothing to laugh about.

Shall we?

THE END